Carl Larsson A HOME

With paintings by Carl Larsson

and a text by Lennart Rudström

Translated by

Lone Thygesen-Blecher

First American Edition 1974. Illustrations copyright © 1968 by Albert Bonniers förlag. Text copyright © 1968 by Lennart Rudström. English text copyright © 1974 by G. P. Putnam's Sons. Picture reproduction is with the approval of the National Museum where the original paintings hang. All rights reserved. Published simultaneously in Canada by Longman Canada, Limited, Toronto. SBN: GB-399-60891-5 SBN: TR-399-20400-8 Library of Congress Catalog Card Number: 73-91718 Printed in Portugal, 1977 by Gris Impressores. Fourth Impression.

G.P. Putnam's Sons New York

Have you ever heard of Carl Larsson, the painter? C.L. was the way he signed all his pictures. He lived here in the town of Sundborn in Dalarna (in the western part of Sweden), and it was here that he got the subjects for the paintings in this book.

Carl Larsson came thundering across this bridge many times in his horse and carriage. Exactly like Grandmother and Grandfather in the picture.

Carl Larsson was a painter who traveled a lot. One day he was in Stockholm, the next day in Göteborg, and the next week in Paris or Rome. And he painted and drew everywhere he went. But the first time he drove across the bridge was in 1885 with his father-in-law. They were on their way to the farm, Little Hyttnäs (The-Hut-on-a-Point), to visit Karin's two aunts. Karin was Carl Larsson's wife.

First you took the train to Falun. Then you had to take a horse and carriage for another hour and a quarter. It rattled and bumped up and down the long hills, and the dust flew around the wheels. Way up the ridges you could see the blue mountains in the distance. In the valleys the air was still and the sun was hot. The first time Carl Larsson drove across the bridge the river roared wildly. In those days there was no power station, and in the flume the timber rushed with dizzying speed down to the sawmill.

A pig might meet them by the bridge and follow them down past the manure pile and across the neighbor's backyard—but he couldn't go any farther than the farm's green gate.

"Karin ought to see this," Carl Larsson shouted when they came down to Little Hyttnäs, just where the Sundborn River curves and starts flowing quietly. So the next time Carl came back he brought both Karin and little Suzanne. Suzanne was Carl Larsson's first daughter. Little did they know that they would drive across the bridge many, many times, in both rain and sun.

Carl Larsson painted all the pictures in this book in watercolors. An artist who paints with watercolors can use them in many ways: He can paint thinly so that the paper shows through. He can paint thickly and mix the colors with a little white thickener now and then. Or he can leave areas of the paper blank so that it shines beautifully against the colors. This is what Carl Larsson often did. You can also work with watercolors in other ways: You can paint flowingly on wet paper so that the color spreads around, or you can drip and sprinkle the color on. You can paint directly without first making a sketch, but Carl Larsson chose to do a sketch with a pencil or India ink before he put his brush to paper.

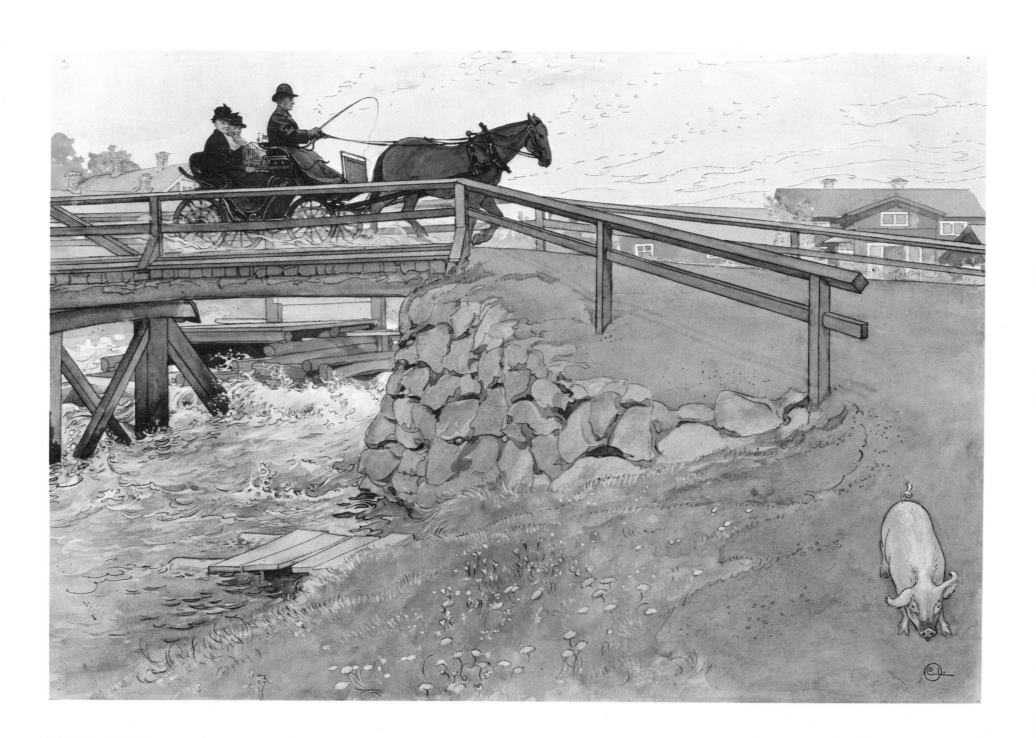

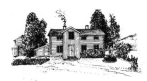 One day when Carl Larsson was in Paris painting, he received a letter from his father-in-law telling him that he and Karin had just been given Little Hyttnäs as a gift. Actually, it was a pitiful little house situated on top of old slag from a foundry. A little earth had been moved there to grow some potatoes, and nine birches grew in the slag. A couple of lilac bushes bloomed in midsummer and smelled lovely.

This would be a good place for an artist to live, thought Carl Larsson. *But if I'm going to work there, I'll have to rebuild it.*

So that's what he did. Every summer he added a little, built something here, and painted something there. He got some help from Arnbom, Elfström, and little Backström, some of the neighbors.

As his family grew, he added to the house seven times. And as his paintings grew larger and there were more and more of them, he decided that he needed a large studio. So Arnbom and Elfström and Backström continued to saw and build, and bricklayer Jansson came to build a chimney and a large open fireplace in the studio.

The citizens of Sundborn scratched their heads and thought that the painter was a strange fellow. They also thought that he rebuilt his house in an ugly way—there were all sorts of passages, and added rooms stuck out everywhere, and the whole place was filled with wood carvings and paintings. On the roof were the most wonderfully carved wooden dragons.

But one day, when the citizens of Sundborn came to the Larssons for a party, they saw a sign over the entrance to the studio:

CARL LARSSON AND HIS SPOUSE
WELCOME YOU TO THEIR HOUSE

All over the house were the prettiest summer flowers. When the guests entered, they could tell they were in the home of a real artist.

When Carl Larsson moved up to Little Hyttnäs in Sundborn, he didn't have much space in which to paint. He had room to do the drawings and watercolors and small oil paintings, but when he started his big sketches for wall paintings, he decided it was time to build a studio. You can see it in the picture. One whole wall was windows so that he would have a lot of light. But when he started the sketches for the entrance hall of the National Museum, he still had to rent an apartment and a studio in Stockholm. Several years later he built a much larger studio at one end of the house. It had a very high ceiling. Now he wouldn't have to rent space in Stockholm for his larger work.

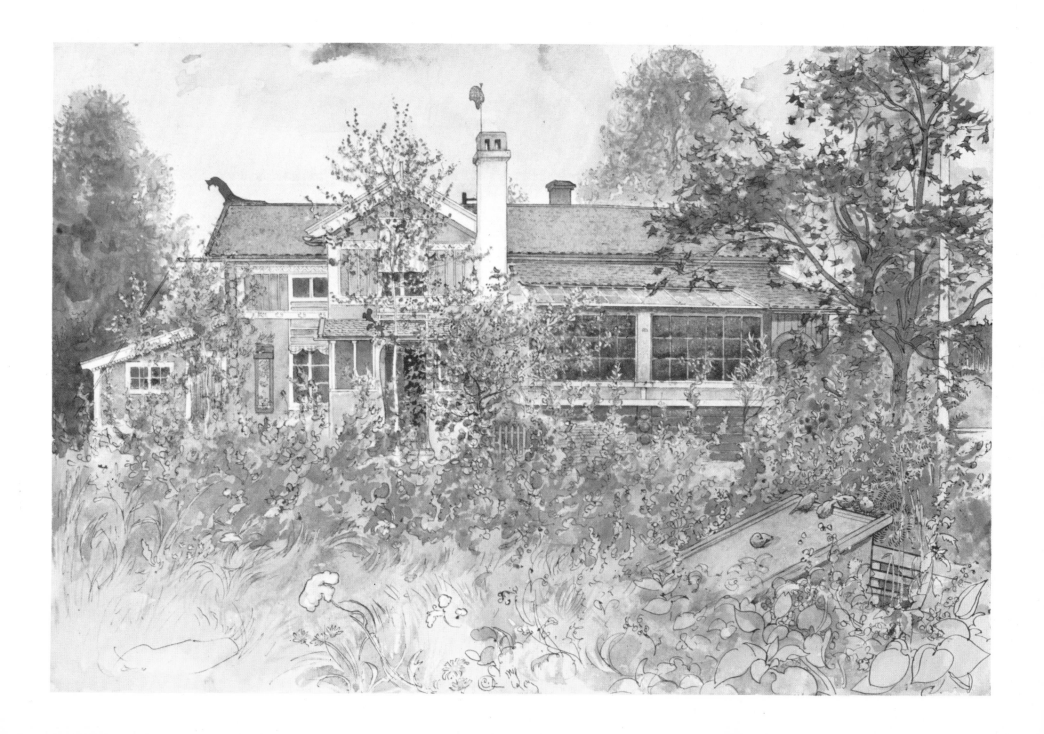

You can surely tell that a painter lives here. In the middle of the floor there is an easel with a study of Lisbeth and her doll. The paint box is on the table with paper, chalk, and India ink. There is also a box with watercolors and brushes made of squirrel fur and some made out of the marten's tail fur, which were very expensive.

In the corners stretch frames and canvases of all sizes are leaning against the walls. The painter cuts the canvas so that it fits the frame, and then he nails it on with copper nails so that it fits tight. If he hasn't primed the canvas with thin oil paint, he does it now and puts it against the wall to dry.

In the corner you can see the painter's parasol, which is nice to have when the sun is strong. It throws a good shade for Carl Larsson when he sits out in the pasture or when he's painting the breakfast table under the large birch trees.

Carl Larsson is also a wood carver and a carpenter. On the wall he has a whole carpenter's shop: a saw, a plane, a chisel, a drill, a screwdriver, and a ruler. He makes dragons and old men and birds, and he puts them all over the house, inside and out. When he is too tired to paint, he relaxes by making these things. At least that's what Karin said. The carpenter, Kvarnberg, said that Carl Larsson never sat still. There was always something that had to be done. And it had to be done now.

What time of year is it? Carl Larsson has been in the garden to pick a sunflower and he has put it in the middle of the table with a few wild flowers. A pine tree stands on top of the corner cupboard. In the middle of the summer? He probably dug it up when he took a walk in the woods and put it there because it smelled so good. But this room doesn't smell only of flowers and pine; it smells of oil paint and turpentine too. For this is a painter's room.

Carl Larsson painted and drew both small and large pictures. He drew old men, serious and happy, for newspapers and books, and he painted watercolors and oil paintings. Sometimes he painted directly on the surface of a wall like the painting he did in the entrance hall of the National Museum. Large scaffolds were built for him and the Italian painters who helped. When there were large wall paintings to be done, the artists often had help from specialists in Italy. Carl Larsson was helped by Antonio Bellio, who knew all about fresco paintings: which colors to choose and how to mix marble dust in the finishing coat to get a fine surface. But when Carl Larsson did the small watercolors for this book, he could sit with the drawing board on his lap and the watercolor box and his cup of water on a stool next to him.

But this is not all of the studio. If you turn around, you can see the whole thing. Over there to the left sits a model, old Anna. She is waiting because Carl Larsson just went out. The door is still open; he's taking his time. Anna looks at the picture of herself. Is she going to be beautiful? No, she doesn't look that old, does she? And the nose—she thinks she has a much prettier nose than that. She looks again and again, very carefully. But this is only a sketch done in charcoal; Carl Larsson has just started. It will be hours and days, perhaps a week, perhaps two, before he finishes. The same light on the canvas, the same light every day on Anna's clothes—he likes slightly overcast days best of all, for that is the best kind of light for a painter to use.

Up there in the little window to the right—which can be opened from the painter's bedroom— somebody is looking out. Is it Ulf? He is probably asking Anna if she thinks the picture is going to be nice. How do you answer such a question?

Here in his studio, Carl Larsson has been doing a lot of carpentry, wood carving, and painting. He made the sofa in the corner and painted it red. One corner post goes up almost to the ceiling. In the post he has put a small door, and in this little closet he keeps all his tubes of oil paint: cadmium yellow and cadmium red, cinnabar, English red, Parisian blue, cobalt, ultramarine and emerald, umber and burnt umber, ivory black, and all the others. On the inside of the door he has written in pencil all the names of the colors and where they are supposed to be. On top of the post, he has put himself, carved in wood and painted red, ugly and angry, with a hat on his head and leaning heavily on a stick.

But on the door he has painted Karin, sweet and delicate, much prettier than the old man on the post. At least that's what he thinks.

It's hard to paint large oil paintings, especially if the painter is working out of doors. The paint box is heavy, and the canvases can be large and heavy as well. The easel can't be too light either because the smallest wind would blow it over.

Just like most other painters, Carl Larsson had a large easel in his studio and a smaller one which he took with him when he went out to paint.

All paints are made of plants and metals. In the color powder you put different kinds of adhesive for it to stick to surfaces. In watercolors you use glue and honey, in oil paints linseed oil, in tempera egg white and oil. Watercolor brushes are made of squirrel hair or marten hair and oil-paint brushes of bristles or cow hair.

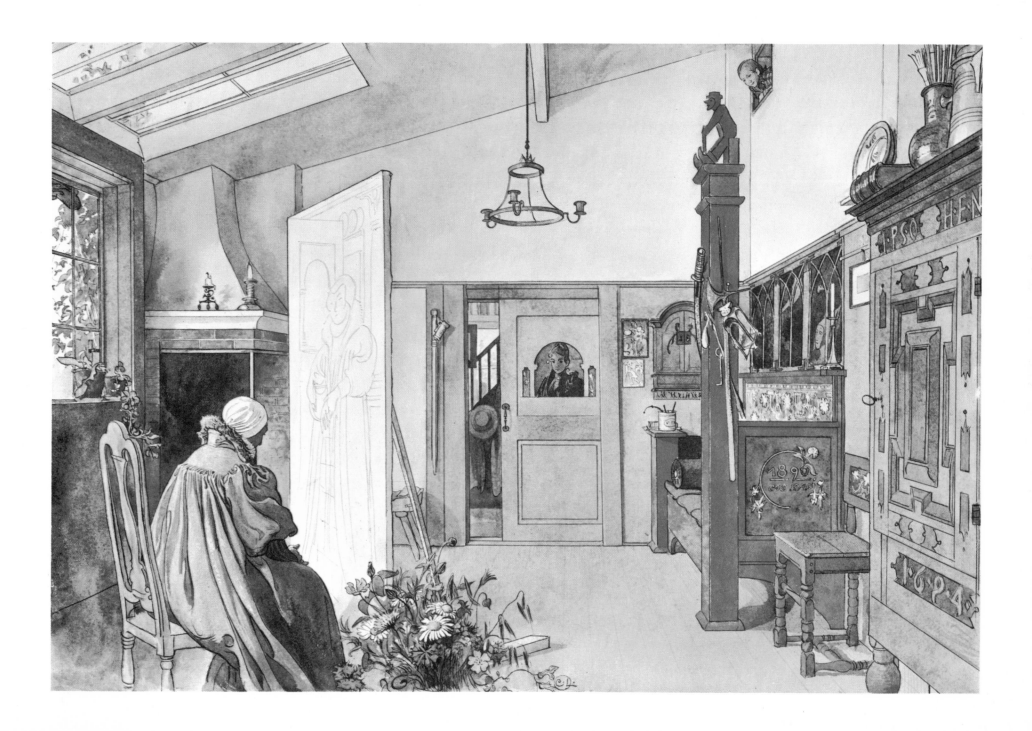

Here they are now: Carl and Karin. They sit in the dining room for a while in the evenings when all the children are in bed. Carl is reading aloud to Karin while she is mending all the holes and tears in the children's clothes. It is wonderfully quiet when all seven children are sleeping. No crashes and bangs. Only a little rustling in the walls, a gentle summer rain, or perhaps the howling of the autumn wind. Sometimes you only hear the silence and the distant roar from the river and the timber flume.

Carl and Karin lived here at Little Hyttnäs for thirty years. Of course Karin more than Carl, because he was often away on a long trip.

Carl Larsson was originally a city boy; he was born in Prästgatan 78 in the Old Town in Stockholm. Sometimes the Larsson family had a hard time. His father would suddenly leave home and stay away for a long time. Then his mother and the children would have to take care of themselves as best they could. After Carl had studied at the art academy, he packed his bag and traveled to France. For a long time he lived in a small town called Grez. He loved it there—it was quiet and peaceful, and he could get a lot of work done. And it was there that he met Karin; she had also gone to Grez to paint.

When Carl Larsson arrived at Sundborn in Dalarna, he thought it reminded him of Grez. He wanted to live here. But how he started to paint everything around him is another story.

One summer it rained almost every day. Everything was gray and sad. Carl Larsson walked up and down in his room and got more and more angry. If he went out to paint, it would start raining as soon as he put up the easel and the parasol, so all he could do was pack up and run back inside. He couldn't paint in weather like that. It rained for six weeks straight. Then Karin said to him: "Why don't you try to paint the things around you—the children, the flowers, the furniture, the paintings? Why don't you paint interiors?" So that's what he started doing, and he painted them all summer.

The first person who had recognized Carl Larsson's talent was Corporal Ärtman. He had become Carl's friend when Carl was a boy. He brought Carl pencil stubs and old notebooks from the barracks to draw with. Ärtman was strict. He corrected Carl when he thought he didn't draw something well. But he was a good friend for a little boy to have.

Carl painted and did woodcuts all the time. One day he went inside the wood shack and carved King Gustav II in a piece of wood. It looked just like him. Carl Larsson wrote that before he started drawing, he was always cutting men out of his father's newspapers and books. He cut and cut, and often he got so tired that he would fall asleep in the middle of the pile of cuttings.

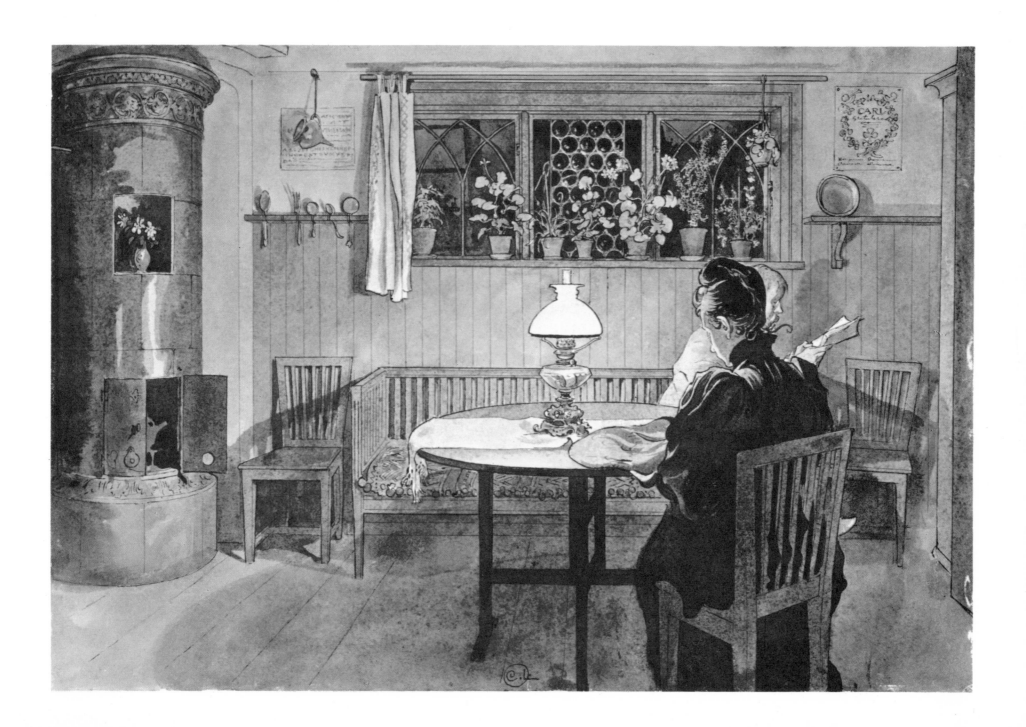

Actually the first painting in this series was "The Punishment Corner." Pontus had been silly at the dinner table that night, so he was sent to the drawing room to sit in the corner. He was sitting in a lovely room. Carl Larsson must have thought so, too. When he came in a little later to get some pipe tobacco and saw Pontus sitting there brooding, he thought he looked so interesting against the wall with the door on one side and the tile stove on the other he started to paint him.

Poor Pontus had to sit in the corner for a long time because Carl Larsson was an exacting painter. Later Pontus said that it ought to be against the law to have to model during the summer.

Still, it couldn't have been all that bad for Pontus. Every time Carl Larsson dipped the brush and mixed colors he could look around the room and relax. The old tile stove was decorated with cocks and flowers and hearts and a kind of terrible creature with horns and wings. And Carl Larsson had added more flowers and leaves around the tile stove by the ceiling.

On the door he had written something in English: "There was a little woman, lived with C. L., and if she is not gone, she lives there still—very well."

On one of the door panels Pontus could see a flower and a portrait of Karin, whom the poem was about. While Pontus sat there, almost falling asleep, he could listen to the clock, the regular, soothing sound of the pendulum swinging back and forth. Pontus would sigh and think: *Why does one always have to model, hour after hour, day after day?*

And especially during summer vacation.

Over the years, Carl Larsson painted many models, both nude and dressed. But his most important models were always his wife and children. They modeled for large wall paintings and for book illustrations. These were books that were about the family and the house and the town. Because of these books, everybody knew how the Larssons lived and how they furnished their house. Carl Larsson was known not only as a painter and a writer, but also as one of the foremost interior decorators of his time. Carl Larsson had started something completely new: making his furniture himself and painting it all in bright colors.

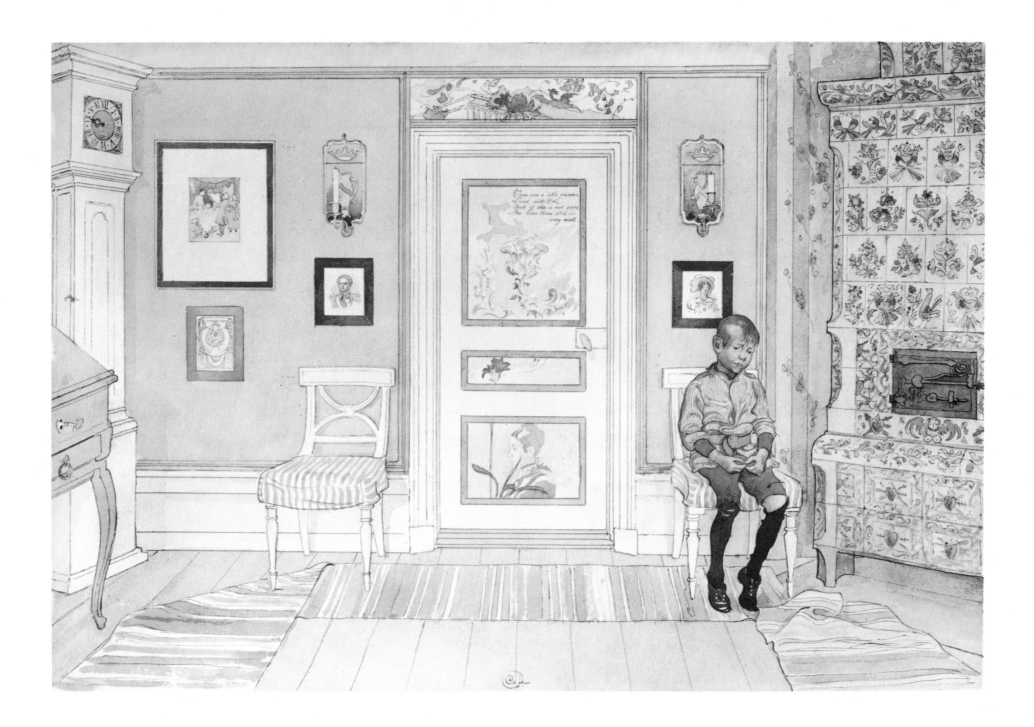

Carl Larsson must have liked this room a lot. He did three paintings of it: Pontus in the Punishment Corner, Suzanne at the Flower Window (this picture), and the Lazy Corner (the picture on the next page).

Pontus could watch the clouds drifting by outside the window from where he sat on his chair. Outside ran the river, and in the river was Rumble Island, the best island in the world. It was the Island of Freedom, which everybody owned: Ulf and Suzanne, Pontus, Brita, Lisbeth, Kersti, and Esbjörn. The little boats called punts shuttled back and forth all day. Rumble Island could be the Bathing Island, or the Indian Island, or the Gloomy Island when the thunderstorm clouds rose above the mountain. On Rumble Island you could make as much noise as you liked. You can tell that from its name.

But how did Carl Larsson get the idea of painting "The Flower Window"? Well, nobody knows. Maybe he was taking a nap in the Lazy Corner sofa one day when Suzanne came in to water the flowers, and he turned his head a little and looked at her and thought how sweet she looked standing there in her pretty dress, watering. And then he said to her that he just had to paint this, and he went for his pen and ink, paper and paints. He sat down, squinted at the light from the window, walked over, and put Suzanne in exactly the position he wanted so that she would get just the right lighting. The painting was going to be beautiful.

He would first sketch with pencils, then draw with ink, and later paint with watercolor. That was the way Carl Larsson would work when he was doing this kind of picture. It took time; it wasn't finished in a hurry.

But Carl Larsson knew how to cheer up his models; he would joke and tell stories. Suzanne was proud of being a model. And of being alone with Papa, when he was painting and happy.

Most houses around the end of the nineteenth century were dark and gloomy. Almost everything was in muted colors. Then along came Carl Larsson, who painted his walls with light and cheerful colors. His windowsills, panels, and furniture were painted white, red, green, or blue. Some things had colorful stripes—the chair covers and bedspreads and the rag-strip carpets.

Karin Larsson wove tapestries now that she didn't have time to paint so much. She wanted to do patterns that were different from Carl's wall decorations—geometric figures in clear colors. Karin drew them with charcoal and chalk on wrapping paper and then pinned them up on the wall behind the loom. Then she would start weaving.

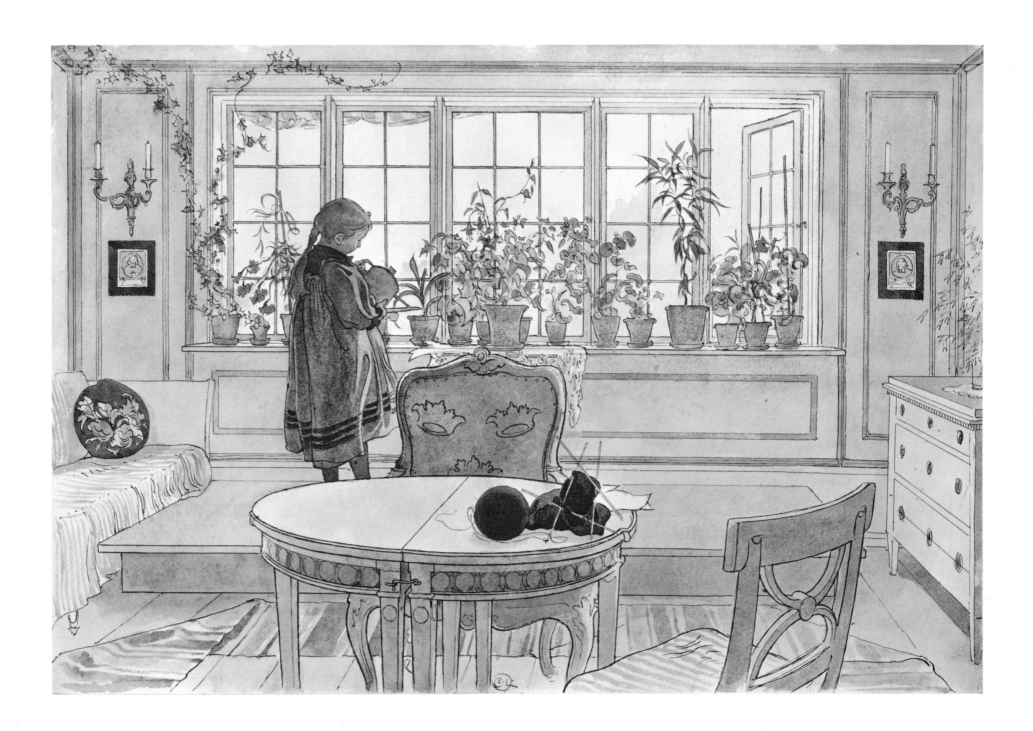

This is the Lazy Corner, the most important place in the room for those who worked hard. At least that's what Carl Larsson thought. But he thought that he was being terribly lazy when he took time off to lounge on the sofa, kick off his slippers, put his pipe in his mouth, and throw on a blanket. But he took comfort in the fact there was somebody even lazier than he—namely, Kapo. Kapo was the kind of dog that just lies there stretched out on the floor, sleeping all the time. Now and then he would open one eye to make sure everything was as it was supposed to be: that master was on the sofa or standing by the easel. Then, once he was sure that everything was all right, he'd see no reason to open the other eye. He dozed off again and dreamed that he was chasing chickens in the neighbor's chicken coop. And his feet would jerk and twitch in his sleep.

Aside from their "laziness," Kapo and Carl had something else in common: They both loved to eat chickens. Kapo couldn't look at a chicken without wanting to gobble it up. And he was equally happy each time he managed to make off with one. Then he would wag his tail and think that the chicken tasted delicious. Carl understood him very well.

This is one of the few paintings without any people in it. But there was a person in it a moment ago. Carl Larsson painted it exactly as it looked just after he got up from the sofa and went to get his painting paraphernalia to start the picture.

For this was a Lazy Corner, and it was *supposed* to look like one.

To Carl Larsson there was nothing that you couldn't paint. He painted everything he liked, and he liked almost everything. He said that when he was a little boy, he painted only officers and pears because they were the things he liked best.

Karin and Carl worked a lot. Carl Larsson is known as one of the most industrious artists in Sweden. He was always painting. There were jobs he did where he didn't even have time to take a rest. He tells about the large fresco in the hall of the National Museum. He started it in the spring and finished it in the fall. And he worked almost around the clock. Antonio Bellio and his helpers came at four o'clock every morning to apply a layer of wet plaster and marble dust which Carl Larsson could paint on. They put on exactly as much as he was supposed to do in a day. Now and then he would have to stand in the same spot for sixteen hours so that the foundation wouldn't dry out. Tears would run down his cheeks from exhaustion. If he didn't have time to finish before the plaster dried, they would knock down everything and he would have to start over the next morning.

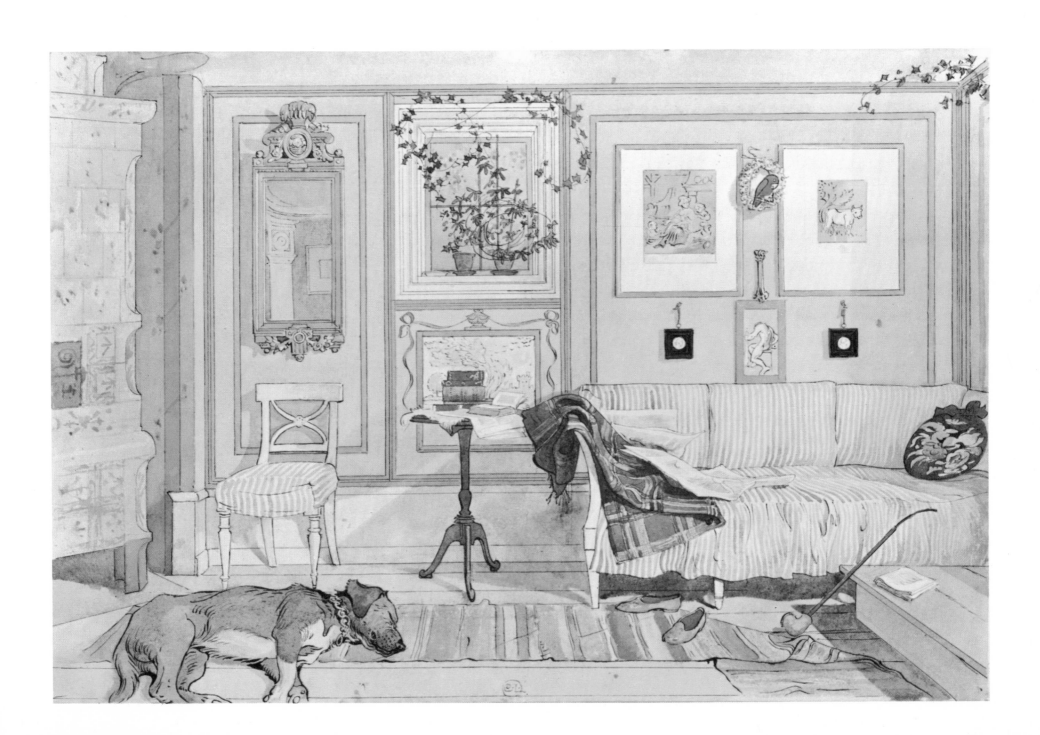

The kitchen was the only room where Carl Larsson and his helpers hadn't sawed and planed and carved and painted and changed everything. Both the maid and the cook, Anna and Emma, thought that it was the only room in the whole house which hadn't been ruined. Well, of course, a little something here and there had been improved, but still, it was the old kitchen. Except for one place—the kitchen stove—and that had made Carl furious.

It happened this way: One winter when they'd all gone away and the house was getting a little face-lift, someone tore down the old kitchen fireplace made out of big boulders and put a pitiful little iron stove in its place. That was supposed to be modern and the thing to have at the time. In place of the beautiful stone chimney, they put up a sheet-metal hood.

Now Carl Larsson got angry. He took the boulders and dragged them down to the cherry bushes. There he built a bench and a table where you could sit and drink coffee and juice on summer afternoons. At least that was a little solace, he thought.

But otherwise, everything was as usual in the old kitchen. The water barrel was in the corner, next to the spice board which smelled of thyme, sweet marjoram, carnation and ginger, mint and chervil and vanilla and many other flavorings. You could go there and breathe in the smell of the spices when you felt like it. In front of the window was the drainboard; there you washed the dishes in the zinc basin. The pots on the stove were made of iron, and the kettles and coffeepot of the most beautiful copper. Copper had to be polished and rubbed to keep it looking shiny and pretty.

This is where Anna and Emma would cook all the food when there were big parties at Hyttnäs. That happened a lot. Just think of all the big parties where all Sundborn was invited and Johan brought his violin. But when Carl Larsson painted this picture, Suzanne and little Kersti were churning butter in the middle of the kitchen floor on a quiet summer day. It was peaceful on the farm, and the painter could paint without being disturbed.

There was always food on the table at Little Hyttnäs, and it was prepared in this kitchen. Not only the big family had to be fed, but there were also parties for the people of Sundborn, and there were always visitors: other painters, authors, and musicians. Everybody had to be fed. The kitchen looks old-fashioned to us now: You had to carry water in the water barrel; you had to take dishwater out and pour it on the ground. Hot water for dishes had to be heated in the water container in the stove. You fired up the stove with wood. The light was from petroleum lamps.

But it wouldn't be long before the great change came: the dam and the electrical power station in the river.

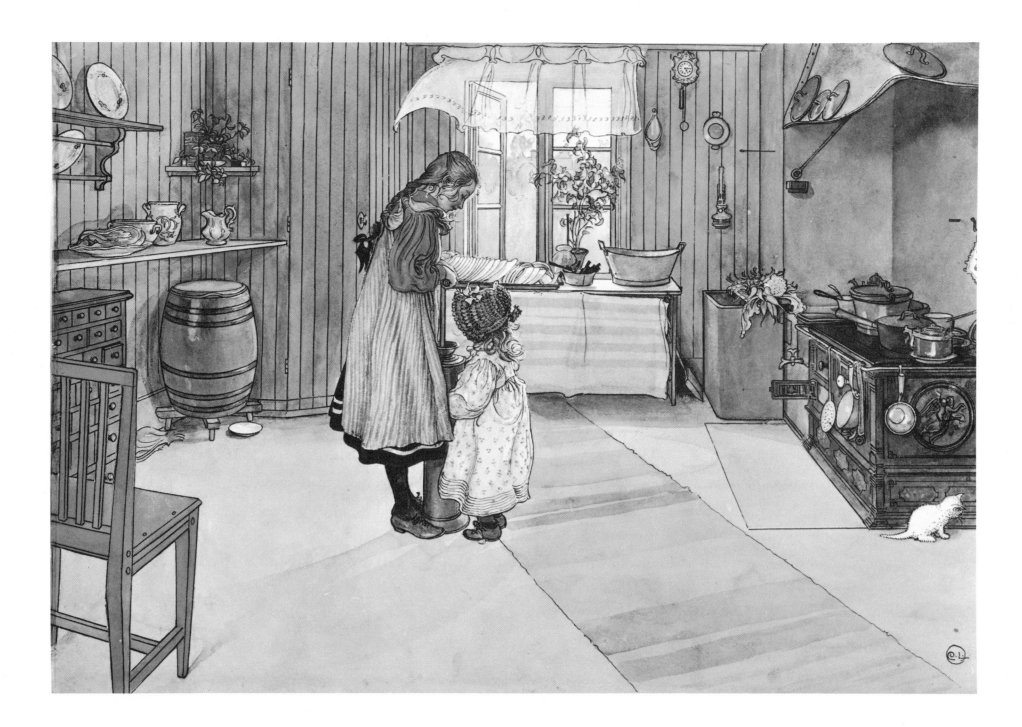

And the cuckoo is calling
To the angel so blue. . . .

This pretty song was composed by Kersti, who is sitting in the middle of the floor in the picture. She made it up one day when she was angry—and a few years older, of course—and felt that she *had* to make up a song.

This is Mama's and the little girls' room. Here Karin lived with her three smallest girls: Brita, Lisbeth, and Kersti.

Carl Larsson has been in here, painting everywhere—walls, doors, even the ceiling. And the closets, of course. You can see that he didn't paint only paintings. First he took out the regular inside ceiling to make the room more airy. Then he covered all the walls, which were newly papered, with a mixture of glue and chalk so that they became quite white. He thought that was much more attractive. Then he painted the prettiest red bows with yellow garlands up near the roof paneling, and after that he took a new brush and painted little green lilies all over the walls. In the shutter he sawed out two little hearts so you could see if it was day or night when it was shut. And way up under the highest roof beam he put up a painting by a painter called Olof Sager-Nelson. It was a painting of a black cat running across a road on a dark night.

This was both a sleep room and a playroom. You washed yourself in the wooden basin. There really wasn't much furniture in the room: just beds, a table, some chairs, a dresser, a washbasin on a pedestal—and a mirror, of course. But it was pretty, and there was room for blocks and dolls and doll beds in the middle of the floor. And you could compose songs here.

Carl Larsson painted this picture on a Sunday morning. Karin had just been ill with pneumonia. Carl had been worried and upset, but now Karin was almost well again. The children had moved back into the room. It was the first happy Sunday morning in a long time.

Because Carl Larsson painted so clearly and with so many details, we know a great deal about the life at Little Hyttnäs in Sundborn—not only about the house and the furniture, but about the people who lived there, too.

This is how it looked on a Sunday morning before everybody was ready and dressed. Kersti had probably been helped by Mama or Papa into her fancy Sunday dress. Lisbeth had finally put on her chemise, her bodice and her pantaloons, her long stockings and high boots. But Brita still has everything to go. She has just gotten out of her nightshirt and put on the thick wool stockings. Is she thinking of putting on her boots before she puts on her pantaloons?

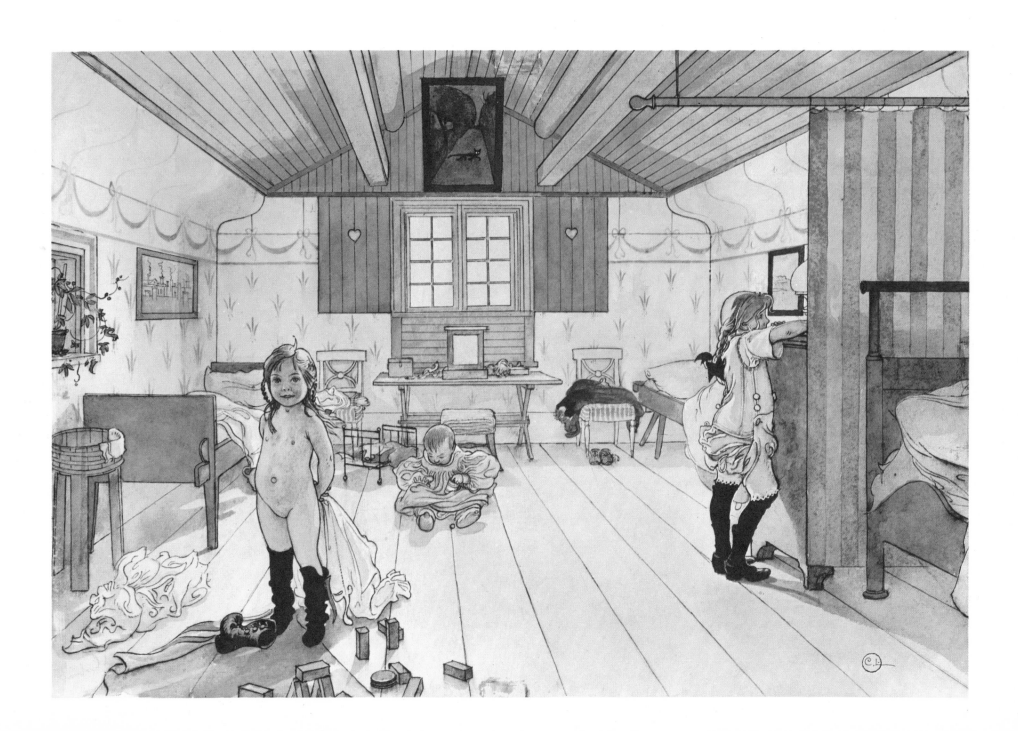

When Carl Larsson had painted Mama's and the little girls' room, all he had to do was to turn around to see another fine subject.

He probably thought that the wall he had decorated was beautiful. Above the door opening he'd painted a lily, some carnations which he'd seen growing on the fields in southern France, and cornflowers which grew in his own meadows. Above everything he wrote: "To Karin, Aug. 1894."

He started out one day when Brita was taking her afternoon nap. She lay there, rosy-cheeked, sucking her thumb. When he stroked her hair, he saw that her forehead was a little sweaty. He started painting. The same garlands and bows that you saw in the previous picture are in this one too, but you can also see a glimpse of Karin's bed, the tile oven and the washbasin stand with the washbasin and the chamber pot. The chamber pot is hidden behind the lovely door that says, "Hyttnäs, Anno 1893." In the middle of the picture you can see a little of Carl Larsson's own bedroom with the big bed that he built himself in the middle of the room. Here he could lie down and look at everything around him, or he could get up and open the hatch to his studio and look through the little window at some big painting he'd finished the evening before. From the hatch he had a good view of the painting; he could decide if it had turned out the way he'd expected or if he'd have to change something.

Above almost every door Carl Larsson painted some kind of curlicue. If it wasn't flowers and leaves, then it would be something he'd written. Above one door he wrote: *"Ved du vad, var god og glad."* That means something like: "You know what I say? Be both kind and gay." Maybe he wrote it as a reminder to himself.

There were not many places in the house which Carl Larsson hadn't painted. Where he couldn't paint, he still made sure that it was beautiful. Since the rooms were heated with ovens, for instance, he saw to it that they were beautiful ovens.

He was proud of his fine tile ovens. He tells how once he exchanged two brand-new (but ugly) ovens for one old beautiful one. He thought that was a good trade. In those days tile ovens were in every house and apartment. If you made a good fire so that the tiles became very hot, you could keep warm all night and into the morning. Tile ovens, fireplaces, open fireplaces, and kitchen stoves were the only sources of heat.

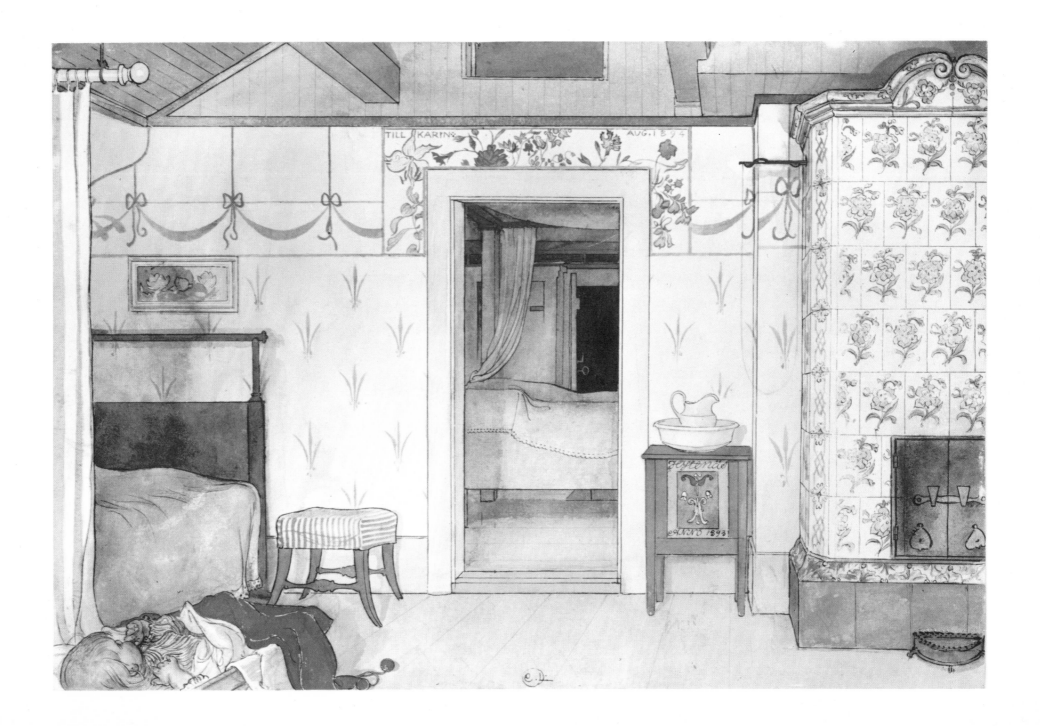

This is the only winter picture in the book. Didn't Carl Larsson like winters? That is not easy to say, but maybe he missed his warm and beautiful Grez in France. Almost all of Carl Larsson's paintings have summer motifs; they are warm and bursting with life. Not only that: He covered walls and doors and closets with pictures of leaves and wreaths of flowers. It had to be summer everywhere at Carl Larsson's house. Maybe it was because he was often happy, but just as often sad and depressed, and he liked to have the gaiety of summer around him so that he would feel better.

Many painters avoid winter motifs. They think that both form and color disappear under the woolly landscape and that the light becomes harsh and flat.

But there is another reason: The days are so short during the winter months in Sweden. Even if the painter hurries and takes out his brushes and paint box just when the sun appears over the pine trees, he won't have much time before it disappears again. Also, you can hardly stay out of doors in the winter; fingers get stiff in the cold, the oil paint hardens and becomes impossible to work with, and the watercolors freeze to ice on the paper.

It is not easy to be a winter painter. You have to hurry out and sketch with a pencil and then hurry home and do some brush strokes.

But when Carl Larsson did this picture, he could sit by the window of the warm little studio and paint the yard and the brewery house.

This is no cold and frozen picture. The sun has crawled up into the birches and is shining through the icicles. The bullfinches have plenty of food in their sheaf of grain. Little Brita walks across the yard with the "skeleton sleigh"; she is warm and snug in her furry Lapp boots. She's on her way to the bakery room in the brewery house; today they are making rolls. You can see the smoke from the chimney.

All the houses on the farm and in the town were wooden houses. They were built with timber from the surrounding woods. You evened down the logs with a wide ax so that they'd fit together a little better when you laid them on top of one another. That was called axing the lumber. Then you chopped out the knots so that they'd all match. The cracks were filled with birch bark and bear moss.

When Carl Larsson rebuilt the main building and lined it with boards, he did something quite unusual. So it wasn't so strange that the people of Sundborn thought that he was a little crazy. But the outbuildings were left just the way they were.

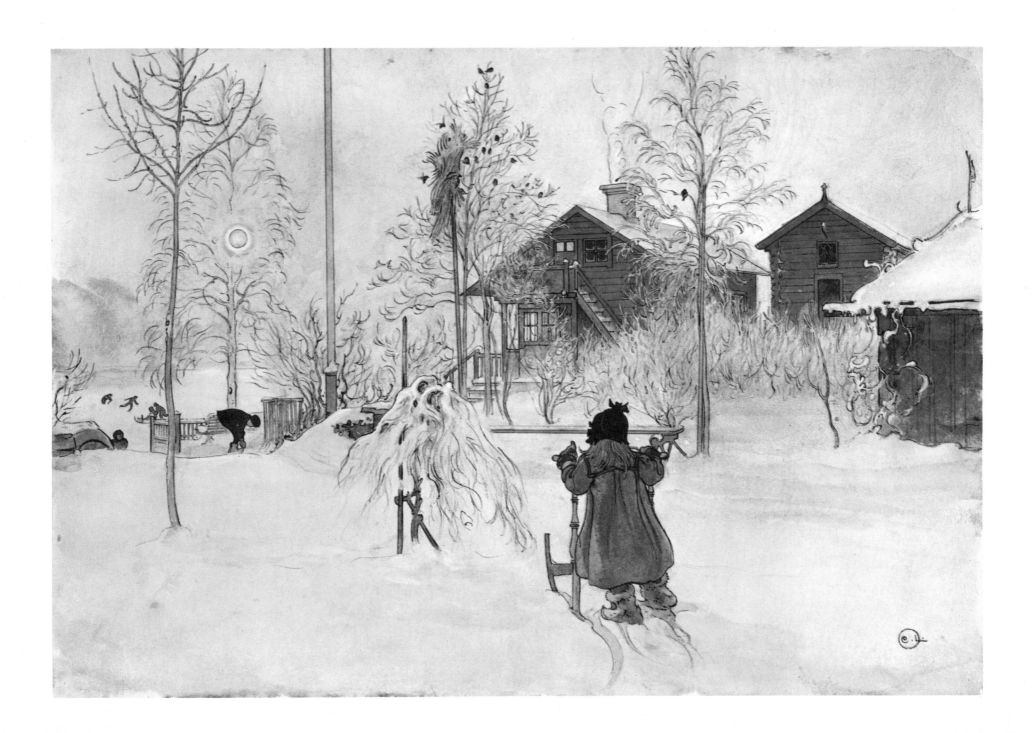

This is Rumble Island, the place the children longed for when they were put in the corner, or had to study, or modeled for weeks on end. When the painter realized that there were other things to paint besides his children, they could row off to Rumble Island, hollering with joy.

This was the Island of Freedom. Everybody thought so except maybe Kapo; there weren't any chickens there!

Of course, Carl Larsson couldn't stay away from the island either. Early in the morning they would load up the two punts with children and row over and swim naked together. The grass would still be wet with dew, and the sun would just barely have had time to warm up the air a little. You could dive with a shriek straight down into the cold Sundborn River. It wasn't warm at all, but in the little bay by Spadarvet, it was a little warmer. There you could jump in and bathe in the middle of the night, when it was pitch-black and nobody saw you and you were all alone with elves and water trolls.

You could live your whole life on Rumble Island if you wanted to. Especially now that the diving board was ready. It was probably one of the highest in the world. So if you had taken enough sandwiches and rolls and cookies along, you could stay as long as you liked.

You could just make out Little Hyttnäs from there. And you could see people in town. Just think: To be here on your own island, where nobody could reach you—and still, only a couple of hundred yards away, there was home, and you could see everything and know that that was where you lived.

Carl Larsson must have painted this picture from memory. He had seen the children dive and swim several hundred times that summer. He had seen them run up the diving board and do a belly-flop or a swan-dive. He had watched them undress and dress again hundreds of times, and he knew how Kapo would usually sit moping, afraid to go into the water.

So when he did this picture, he knew exactly how he wanted it to be. He had photographed it in his mind's eye.

The boats in the river which Karin and Carl and the children used when they went fishing and swimming were real inland-lake skiffs. Here they were called punts; they were flat-bottomed and had built-in oars. That means that there were no oarlocks on them, like the skiffs used in the archipelago and out on the coast. The skiffs on the archipelago had rounded bottoms. This made them more seaworthy.

But on the river there were never any high waves. You could do fine with a flat-bottomed punt. Besides, a punt was easier to use in shallow water and through the reeds.

The logs in the water, which Carl Larsson has painted so clearly, is the timber flume. It keeps the lumber that floats down the river from drifting in toward the beach and getting stuck.

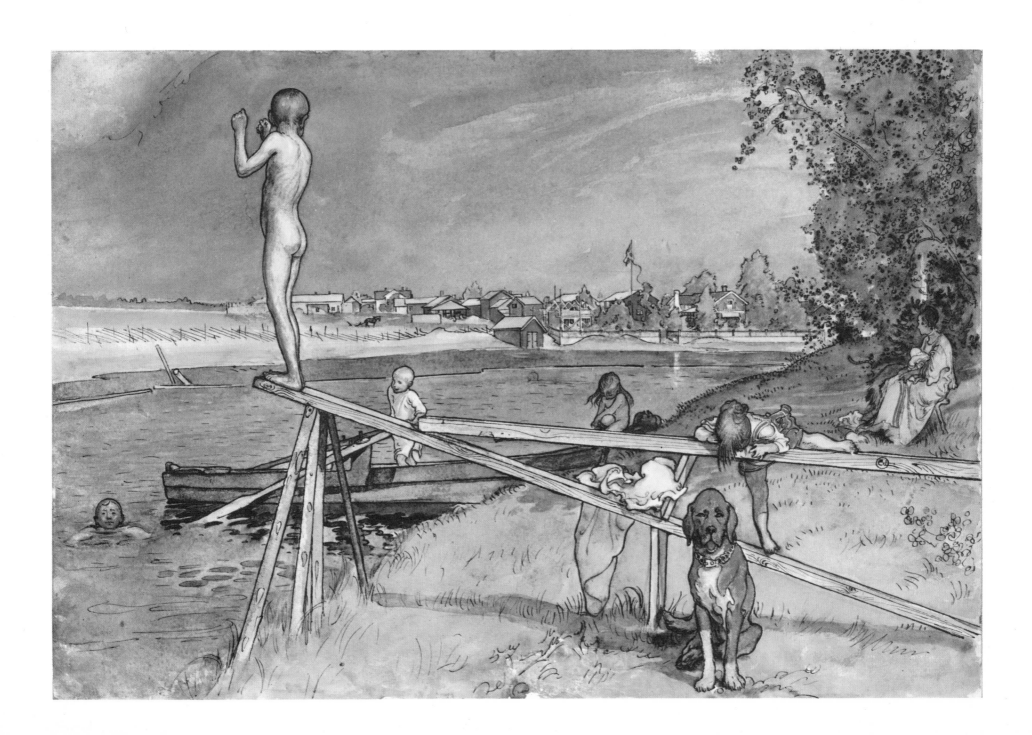

In the beginning of the summer, everybody started talking about August 15. The closer you got to it, the more you would talk about it. And when it was finally August, every rod and trap was taken out. Then finally, on the fifteenth, the great Crayfish Catch began.

When the August darkness fell on the town of Sundborn and the Sundborn River, Carl Larsson went out in the middle of the night with all his rods and crayfish nets. He put them in the punt, and at twelve o'clock exactly he rowed out no matter what the weather was like. If the moon was shining, or if it was thundering and lightning, or if the first fall storm was roaring, it made no difference. The nets had to be put out this first night when it was legal to fish for crayfish. Later he went back to lie down for a couple of hours, and then at five in the morning he got up again and got all the children out of bed. They had to help empty the crayfish traps. While the sun rose above the woods and the haze lifted from the water, the two punts slid out, loaded with sleepy, shivering children on their way to Rumble Island. All you heard were the oars hitting against the side of the boat in the quiet morning. They all hopped ashore, took off their shoes and stockings, and waded out. It was cold.

Then the Crayfish Catch started. Everyone got crayfish in his net, and by the end they had several dozen. Now they would have a party that would last almost all day. First the crayfish had to be boiled. Then they had to set the table, and when that was done, they made coffee. Then maybe someone thought that there wasn't enough bread or beer, and they'd have to row back for more. That's how it always was when you went to Rumble Island. You always forgot something back at Hyttnäs, so you'd have to go back a couple of times. That was part of it all, though. On the way home you would row in circles and figure eights, but on the way back to Rumble Island you could simply drift with the weak current.

It was strange. To row to Rumble Island could take five minutes, but it could also take an hour.

At that time, exactly like now, there was a certain time of year when it became legal to fish for crayfish.

In the picture, Carl Larsson has shown carefully what they used as tools for catching crayfish: rods and nets and traps. To boil the crayfish, you'd use the big iron washing kettle on the open fire. You'd brew the coffee in the copperpot, which is on the fire right now. In this picture, the painter seems to have fallen in love with every detail. He has loved painting the beautiful table, the children in their fine clothes and hats, the leaves on the trees, and the reflections in the water. Everything is so clear and distinct that it is like reading a story about the Crayfish Catch and the party on Rumble Island.

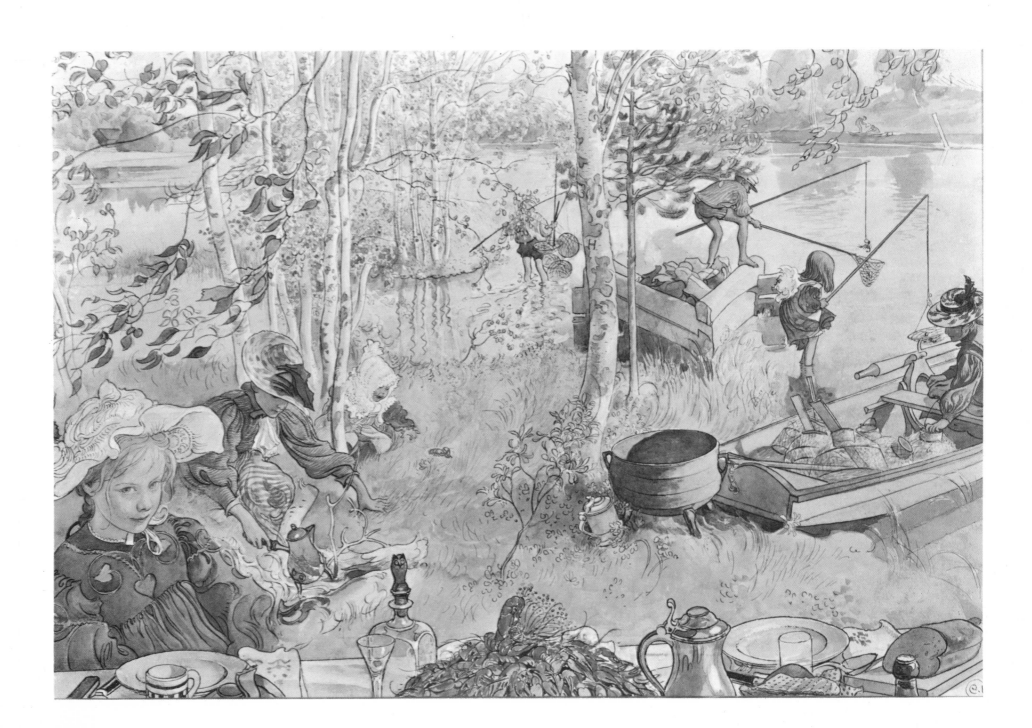

There were many birthday children at Little Hyttnäs. And there were many birthdays to celebrate. Everybody thought that was a good thing. You could get dressed up and sing and recite poetry or play the violin.

This morning on Emma's birthday, Ulf had dressed up as a clown and carried up the coffee tray. Suzanne had dressed up in Carl Larsson's dress suit and was solemnly reading the birthday poem aloud. All the others were carrying wreaths of flowers and bouquets. At the end of the procession came Johan playing his violin. Then tears would start running like peas down sweet Emma's cheeks; Emma liked the violin, and she always shed a tear when she heard Johan playing. Sometimes the boys from Bjus and the miller's daughter Svea would come over, and they would play the "Water Spirit Polka" with both a guitar and a violin. And Anna Sundin who had the prettiest voice in town sang a Sankey song. Then Emma would cry so much that it poured—that is, if none of the boys started shooting and blowing fireworks.

This is how every birthday was celebrated. Even Carl Larsson's. And he liked it. Even if he was a painter who preferred peace and quiet for his work, he still liked many other things. Happy birthdays for people called Karin or Suzanne, Lisbeth, Brita, Kersti, Ulf, Pontus, or Esbjörn. Or Emma, for that matter. And he enjoyed it when all the children dressed up, Johan played his violin, or when someone sang out:

> And the cuckoo is calling
> To the angel so blue. . . .

At Little Hyttnäs there were whole closets filled with old clothes and hats and fake beards. Carl Larsson had collected them over the years. They were clothes he had used to dress up the models for his paintings—historical costumes, for instance, which Karin had helped sew. They were kept around so that the children could get dressed up in them whenever there was the slightest occasion.

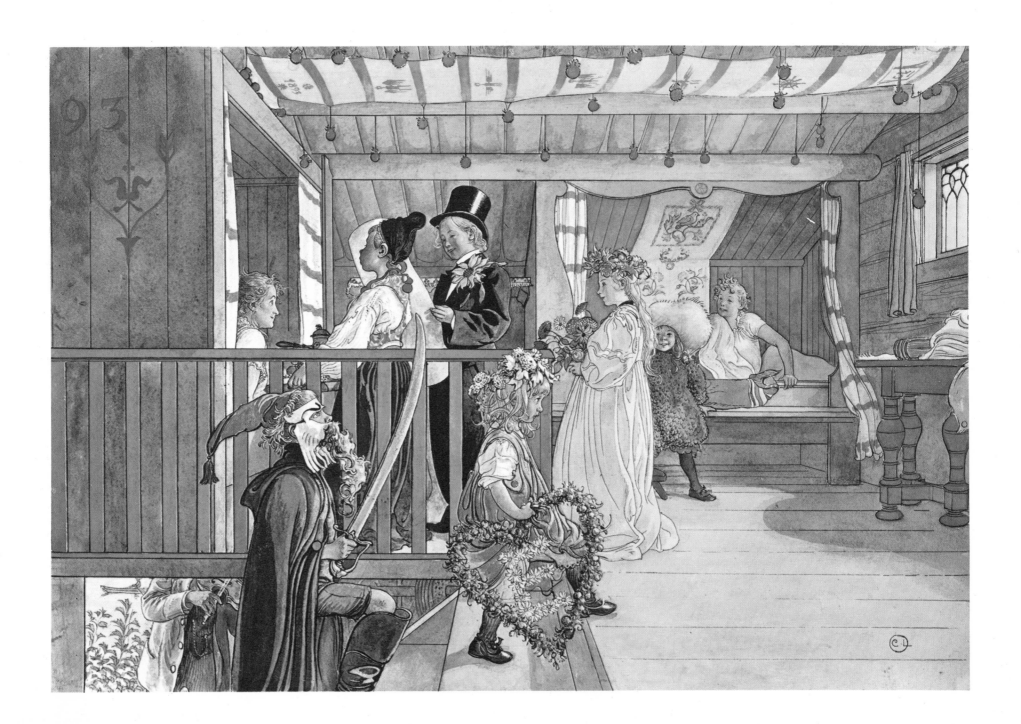